For Kathleen —
w/ Best Regards —

Tony S
10/6/07

Fine Art
Nature
Photography

Advanced Techniques
and the Creative Process

TONY SWEET

STACKPOLE
BOOKS

For Emil and Mary

Copyright © 2002 by Stackpole Books

Published by
STACKPOLE BOOKS
5067 Ritter Road
Mechanicsburg, PA 17055
www.stackpolebooks.com

Printed in China

10 9 8 7 6 5 4

First edition

Cover design by Caroline Stover
Cover photograph of fall reflection on the Saco River, Bartlett, NH, by Tony Sweet

Library of Congress Cataloging-in-Publication Data

Sweet, Tony, 1949–
 Fine art nature photography : advanced techniques and the creative process / Tony Sweet.
 p. cm.
 ISBN 0-8117-2750-5
 1. Nature photography. I. Title.

TR721 .S93 2002
778.9'3—dc21
 2002020203

 ISBN 978-0-8117-2750-1

The Moment
an area is approached,
a line is crossed. Suddenly . . .
shimmering . . . vibrancy . . .
the pulse quickens,
time expands,
compositions self-compose,
exposures self-calculate. The shutter trips . . .
again,
and many more times.
Gradually . . . stillness.
The pulse slows,
time contracts,
calm . . .
settles.

Foreword

ONE OF THE GREATEST BLESSINGS IN MY LIFE AS A PHOTOGRAPHY TEACHER has been the opportunity to see the work of many other talented photographers. I learn a great deal from the work done by my students and colleagues. From my very first exposure to Tony's images I knew he possessed a special vision. Over the years I've been amazed at how his ability to see and translate his feeling onto film has been refined. When one looks at any form of art, there is an immediate connection and response. The stronger the reaction, the more powerful the art. Through the last three decades I've seen a great deal of wonderful photography, but seldom do I stop and absorb the image in front of my eyes as I do when I look at Tony's striking photographs.

It is not enough that we master the technical considerations in photography. The soul lies in the impact of the final image on the viewer. Take some long moments to let Tony's work be absorbed, felt, and enjoyed. There is much to be learned in these pages, but more importantly, there is much to be felt. When we feel our strongest emotions being stirred, we know that we are indeed in the presence of art.

Bill Fortney

Prelude

IT HAS BEEN SAID THAT NATURE PHOTOGRAPHY IS A "LONE WOLF" OCCUPATION. Though the pursuit is solitary in human terms, a nature photographer is never truly alone. When surrounded by a field of flowers or standing on a rocky beach at dawn, while watching a solitary whale breaching in the mist or viewing a spectacular sunset, the photographer is like one member of a vast symphony orchestra: nature's symphony. We are consumed by the ephemeral music of light, wind, clouds, color, texture, form, and sound.

Nature photography is a process of self-discovery and introspection. It instills in us a heightened awareness of the fragility and breathtaking beauty of the world we so fleetingly inhabit. Through photographs we seek to share our intimate visual experience with others. We remind the viewer that this beauty must be preserved and respected, or it will disappear forever.

The irony of nature photography is that we travel great distances in search of subjects and different qualities of light, yet we bring the pictures with us. The images lie dormant inside us long before we ever find "the photograph." It is an intensely personal journey. By creating an image and disclosing part of the natural world, we are also disclosing a part of what is inside us.

The images and descriptions in this book are designed to help you gain greater insight into your own potential for creative and more personal image making.

Tony Sweet

"My first thought is always of light."
 —Galen Rowell

Single Daisy

Worthington Valley, Maryland

Nikkor 300mm, f/4 lens
20mm extension tube
81B warming filter
f/5.6 at $^1/_{125}$ second

Whenever I approach a field of flowers, I look for a single flower with space between it and the flowers behind it to create a muted background. In this case, I used a 300mm lens with an extension tube to isolate the single daisy against a background of sunflowers. The shallow depth of field, inherent with a tele-photo lens, is intensified by the extension tube, which allows for closer focus. Closer focus creates a quicker falloff of the sharpness of the background, caus-ing the foreground flower to stand out in an almost three-dimensional fashion.

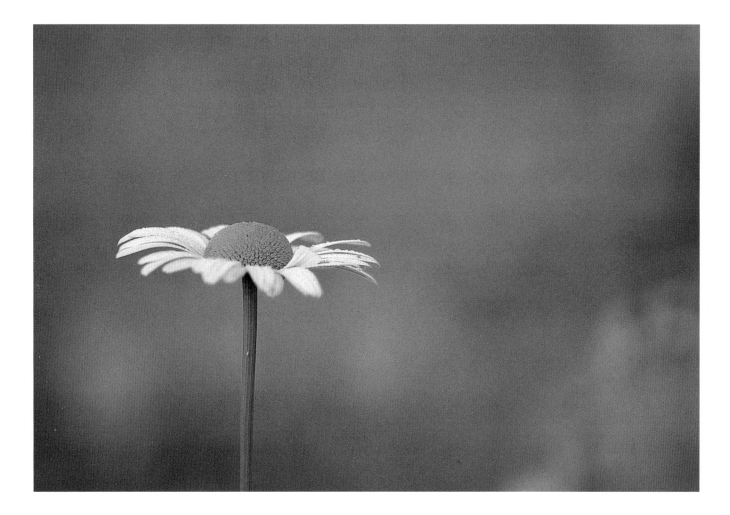

Fall Maple

Bear Notch, New Hampshire

Nikkor 80–200mm, f/2.8 lens
Singh Ray color intensifying filter
f/11 at ¹⁄₆₀ second

The color intensifying filter I used deepens reds, blues, and yellows; in other words, it increases color saturation. I wanted to include as much red as possible in the picture but had to pay attention to rhythm and placement. One of the main things to consider when looking through the viewfinder is what is occurring in all four corners of the frame. Here, I wanted red in all the corners, but I was also searching for a patch of red that was open and well distributed rather than a large block of opaque red leaves, allowing space for the image to "breathe." The tree trunk on the right side, with its branches leaning to the left, gives the illusion of right-to-left or reverse motion.

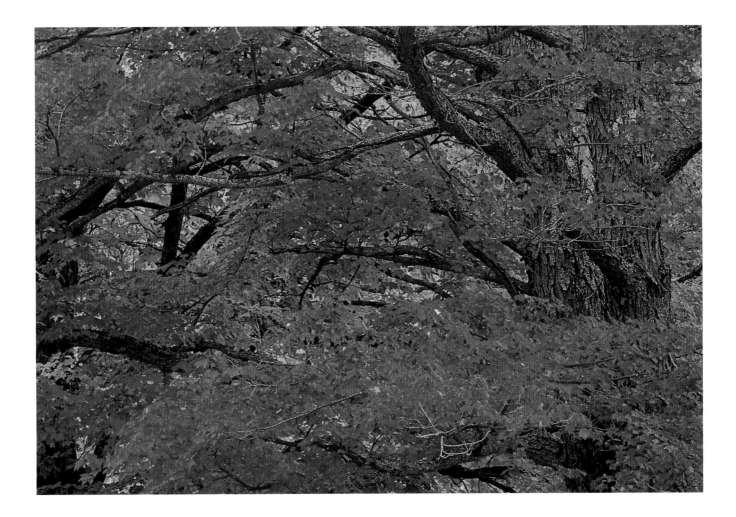

Spring Wildflowers and Grasses at Dawn

Hereford, Maryland

Nikkor 35–70mm, f/2.8 lens
81B warming filter
(Eight multiple exposures at f/16, each at $1/125$ second,
while randomly moving the camera up and down)

Fields of wildflowers are great for multiple exposure interpretations. I selected an area with a group of red poppies, because with all the motion blur, the area of red gives the viewer a visual anchor in the midst of this impressionist image. After scouting the location, I learned that the sun strikes it at first light. The warm, golden tone of the grasses and the vibrant red of the poppies are the result of waiting until the light was beginning to touch the image area. Waiting longer would have resulted in increased contrast, such that the shadow areas would have become black and the color would have appeared hot and washed out.

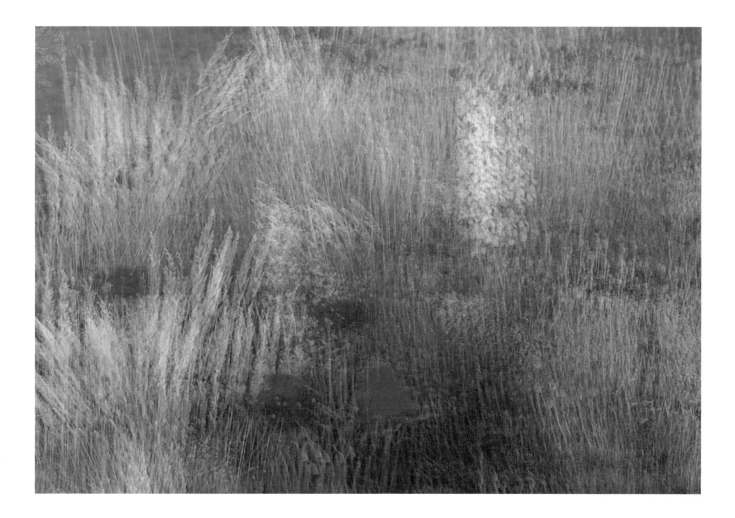

Misty Fence Line

Worthington Valley, Maryland

Nikkor 20–35mm, f/2.8 lens
81B warming filter
f/22 at 1 second

What attracted me first was the strong, rhythmic line of the fence. Mist, which around here often appears at sunrise, is a wonderful separator, accentuating the silhouetted fence line. I always search for graphics such as squares, rectangles, circles, or triangles—elements that are stark and real attention grabbers. The perspective rectangles (the grid created by the fence's construction) are very strong and lead the viewer down the fence line and into the image. I wanted the fence line to enter, pass through, and exit the frame into the mist. Getting close to the fence exaggerated the beginning perspective, adding to the sense of rhythm and graphic contrast.

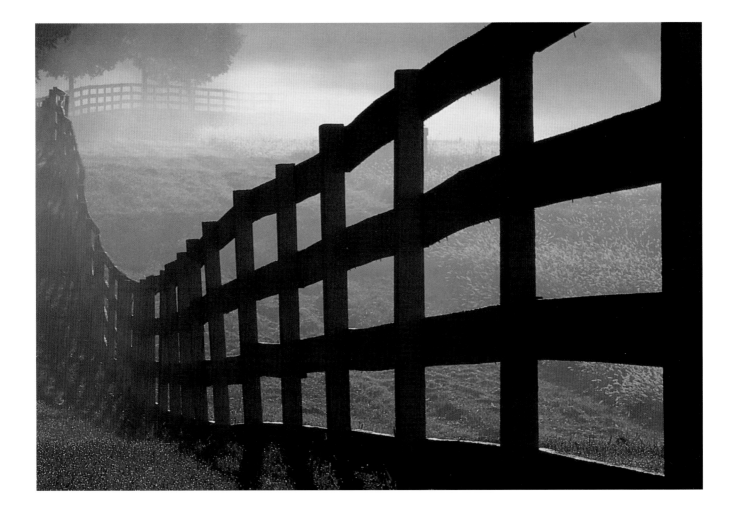

Orange Dinghy

Cape Breton, Nova Scotia, Canada

Nikkor 80–200mm, f/2.8 lens
81B warming filter
f/16 at 1 second

When photographing old fishing villages, I am always on the lookout for a single colorful boat and reflection. A lone dinghy on a placid body of water is calming and moody. In this case, I was set up and waiting for the sun to come out from behind some moving clouds in the hope that it would light up the scene and increase the contrast to punch up the colors. Eliminating the shoreline from the scene and showing only the treeline reflection focuses attention on the boat, which is the only "real" subject. Time is of the essence when the sun shines on a body of smooth water. It's a good thing I was set up and waiting for this moment, because once the sun lit the scene, it was only about 15 seconds before the reflection was broken up by a breeze.

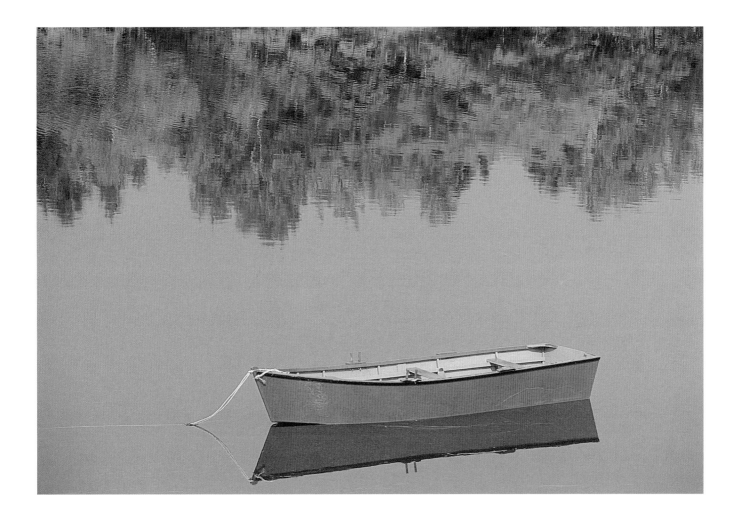

Red Against Yellow

Acadia National Park, Maine

Nikkor 300mm, f/4 lens
12mm extension tube
81B warming filter
f/4 at ¹/125 second

"Always photograph red in nature" is a good idea to keep in mind because red records extremely well in film. In this case, the red leaves against the muted yellow background created an obvious photo opportunity. To get the red to pop and the yellow to go as soft as possible, this image was made with the aperture wide open. The distance between the foreground red and background yellow was close, so I added a short extension tube to allow closer focusing and a faster dropoff of the background. Only a small section of the red is sharp, but it's enough. This image works because of the openness of the red leaves against the yellow. Too much red would have obscured the background, which is just as important. Notice that the red area is sparse and has a nice rhythm. The opaque, soft yellow background seems to light up the image.

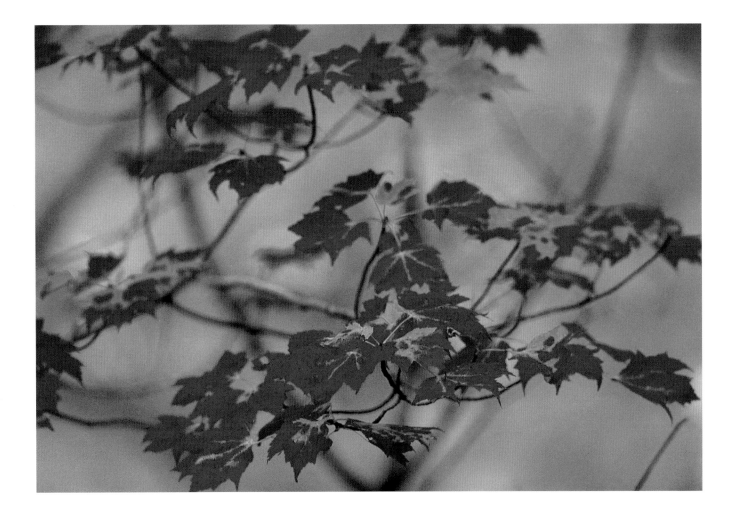

Zen Reeds

Kingston Lake, New Brunswick, Canada

Nikkor 80–200mm, f/2.8 lens
10cc magenta filter
f/8 at 1 second

Reeds, fog, reflection: the essence of simplicity. My goal here was to find an open, asymmetric reed pattern with the sun in the upper corner. Actually, the sun reflection was in the lower right corner, and the image was made knowing that it would be turned upside down and reversed. Having a depth of field of f/8 retained the sun's edge. If this had been shot wide open, the sun would have been a large white hole; stopped down to f/22 or f/16, the sun would have been a hard-edged white dot. The various effects can be gauged using a depth of field preview button, which is not available on all cameras. This was a color-less scene; the 10cc magenta filter added the color.

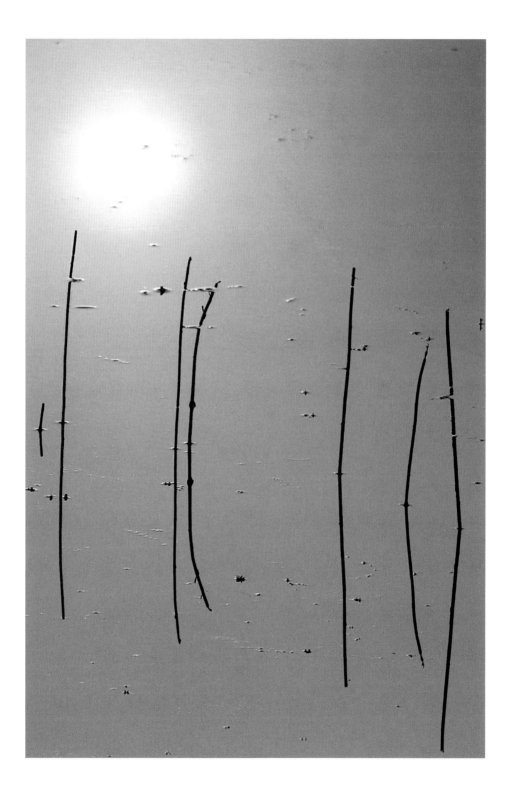

Swan at Sunrise

Cape May, New Jersey

Nikkor 300mm, f/4 lens
1.4X teleconverter
81B warming filter
f/4 at $^1/_{15}$ second

This photograph was taken on the way to the lighthouse at Cape May Point during a workshop. Had I not seen a student parked on the side of the road and stopped to see what was up, I would have missed this. Several swans were swimming around, but the right composition didn't present itself. Just as the sun came up, it reflected in the water, creating a balance between it and a single swan. I waited for the swan to slow its pace, since I was shooting at $^1/15$ second. When it did slow, I moved the camera to put some space in front of the swan, giving it room to move. Weak composition would have resulted from placing the swan too close to the edge because when photographing a moving subject, there should always be space in the direction of the movement or the subject will appear cramped. The mist line separates the swan from the dark background.

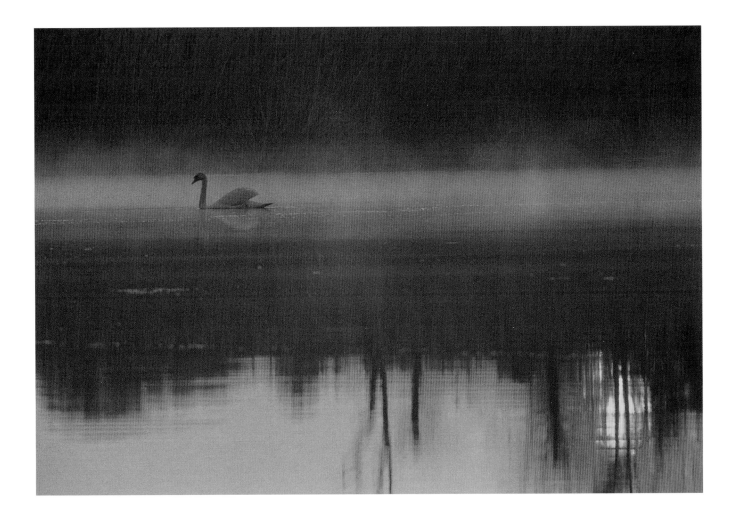

Sparks Lane

Great Smoky Mountains National Park, Tennessee

Nikkor 35–70mm, f/2.8 lens
81B warming filter
f/22 at 1/2 second

This is one of my favorite scenes to photograph in the Smokies. The sun rises to the left of the trees, creating a soft sidelight. Having the fence line perspective begin from the left rather than down the center adds an asymmetry that makes the scene more interesting, and the fence line and trees lead the viewer into the frame. The mist, which occurs often in early spring, adds to the mystique and separates the trees from the mountains—in this case, almost completely hiding the mountains. As a general rule, it is a good idea to keep things out of the center of the frame to avoid creating a static composition. The point of intersection of the fence and the gravel road is in the lower right third of the frame. This exquisite soft light lasted about 15 seconds.

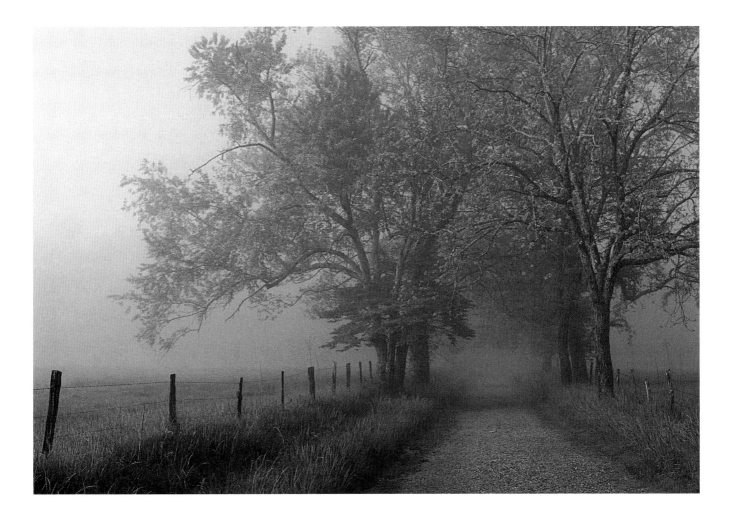

Spring Mist and Dogwoods

Great Smoky Mountains National Park, Tennessee

Nikkor 35–70mm, f/2.8 lens
81B warming filter
f/22 at 1/2 second

Any color with fog is a great situation, as fog softens scenes so that colors stand out. The dogwood whites, the early-spring greens, the spindly trees, and the thin fog work together nicely. Spacing the trees to avoid cutting the frame in half was an issue. Positioning the right spindly tree framed within the tree behind it made the best of a "busy" situation. The main point of this image was to have the dogwood blossoms cutting a diagonal line across the entire frame. Diagonal movement is less static and has more motion than horizontal or vertical movement, making a visually interesting picture.

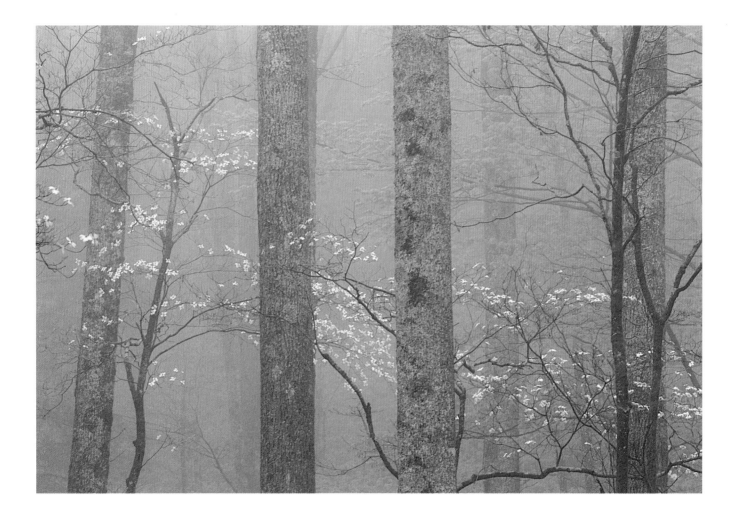

Starfish on Beach

Bowman Beach, Sanibel Island, Florida

Nikkor 105mm, f/2.8 macro lens
81A warming filter
f/22 at $^{1}/_{30}$ second

I had this shot previsualized and set it up after buying a starfish from a shop on Sanibel Island. On Bowman Beach, a western-facing beach, the sun rises from behind the subject. In this image, the ocean is on the right, and the sun is lighting the subject from the opposite side. Normally, the waves and sun are coming from the same direction. The ocean side of the subject is catching the light reflected by the approaching wave, lending a sense of balance to the image. I shot two rolls of film and had to reposition the tripod and the starfish many times. The light was changing rapidly, and the tide was moving in. In the midst of all this activity, I got two usable images. I used a faster shutter speed to stop the rushing wave and preserve its lines.

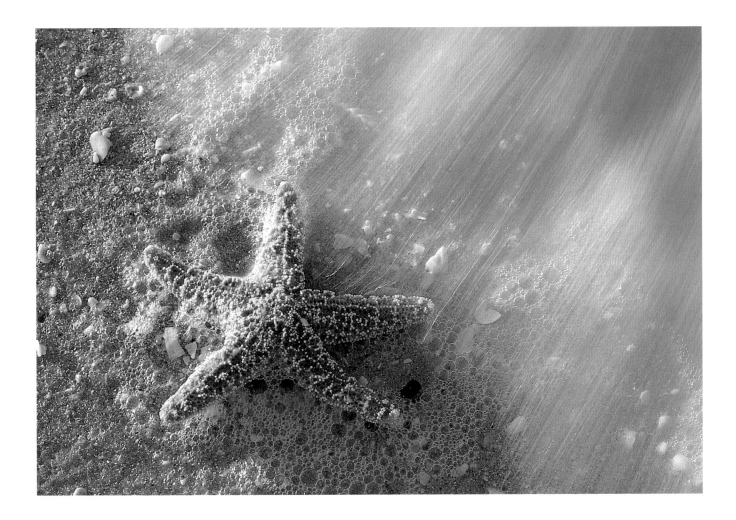

Winter Tree

Pleasantville, Maryland

Nikkor 300mm, f/4 lens
f/5.6 at ¹/₂₅ second

A single tree is always a good photo opportunity—a single tree in snow
is even better. The sun was peeking in and out from behind rolling clouds,
creating patchy light and the chiaroscuro pattern (alternating bands of light
and shadow) in the snow. I was waiting for several things to happen at the
same time, and luckily they did. The sun created the bands of light from
behind some clouds; the tree was in a sunlit band, which created the shadow.
The "horizon line" behind the tree, in the upper third of the frame, is an
optical illusion; it is actually a snowmobile track.

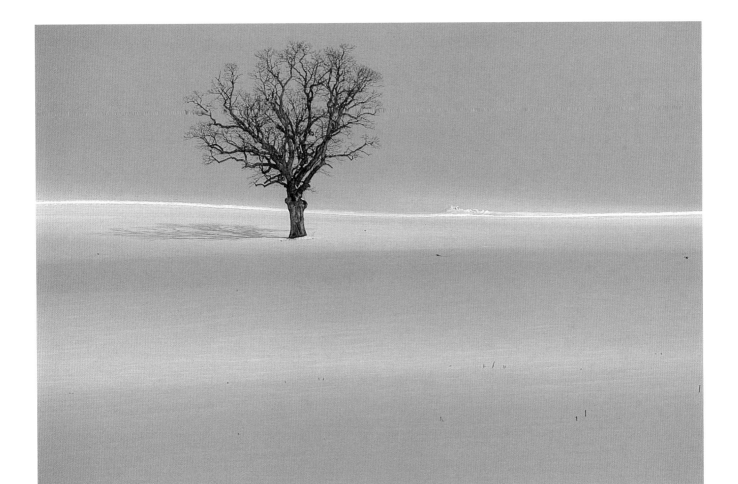

Tree Dance

Everglades National Park, Florida

Nikkor 80–200mm, f/2.8 lens
1.4X teleconverter
10cc magenta filter
f/8 at ¹/125 second

Bright, colorless mist provides a great opportunity to use a colored gel. Adding an amber gel gives a warm tonality, a purple gel gives a magenta tonality, and a red gel gives a red tonality. Any number of filters can also be used to add color to the scene: 81 series warming filters, FLD, FLW, 10cc magenta. The 10cc magenta was my choice for this image; it is light and adds subtle color. Depth of field was the prime consideration, because the sunlight will spread throughout the frame in relation to the f-stop. At f/22, the sun would be a small white dot in the middle of the trees. At f/2.8, the sun would become a large white spot radiating well beyond the trees. At f/8, the sunlight spread just enough to stay within the frame created by the three trees. The effect of each f-stop can be seen by depressing the depth of field preview button.

"Photography for me is not looking, it's feeling. If you can't feel what you're looking at, then you're never going to get others to feel anything when they look at your pictures."

—Don McCullin

Cade's Cove Trees

Great Smoky Mountains National Park, Tennessee

Nikkor 80–200mm, f/2.8 lens
81B warming filter and two-stop split neutral density filter
f/11 at 1/8 second

The mist between the leafless trees in early spring and the mountainside is what makes this image work. The separation created by the mist accentuates the detail and rhythm of the trees. Without the mist, the trees merge with the hillside, and this image doesn't exist. To keep detail in the sunrise sky, I used a two-stop graduated neutral density filter. The tonality of the sky and the mist is colored by an 81 series warming filter. The diagonal line of the mountain is repeated by the diagonal line of the treetops. Such repeating patterns are an important compositional device: they are visually exciting and unify the image.

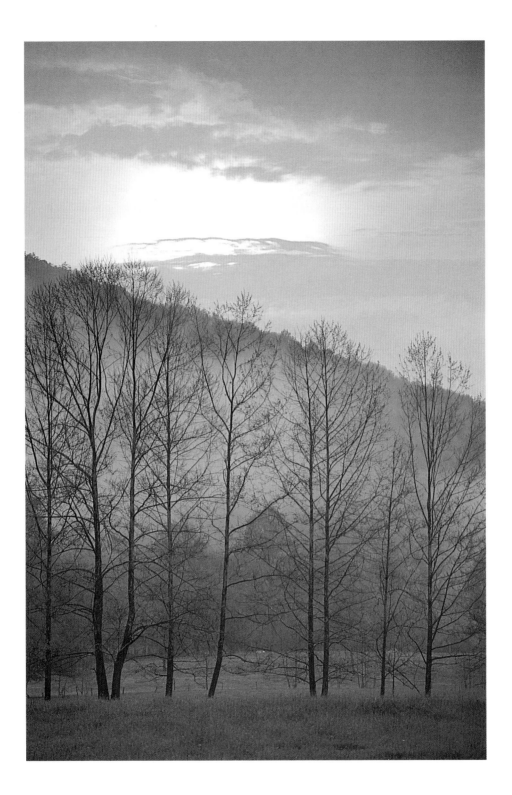

Pastoral Dawn

Worthington Valley, Maryland

Nikkor 80–200mm, f/2.8 lens
Tiffen 812 filter
f/22 at 4 seconds

This image was made in early fall at dawn, when low-lying mist rolls through the valleys of northern Baltimore County. It looks like a landscape painting. The long exposure was used to allow the rolling fog to move through the frame, creating the pastel look of the image. The red enhancing filter bumped up the color of the sky and added some color to the ridges behind the trees. Three trees are shown mirroring the perspective of the silhouetted hillside in the background. I was careful to place the fence line at the bottom of the frame for visual weight.

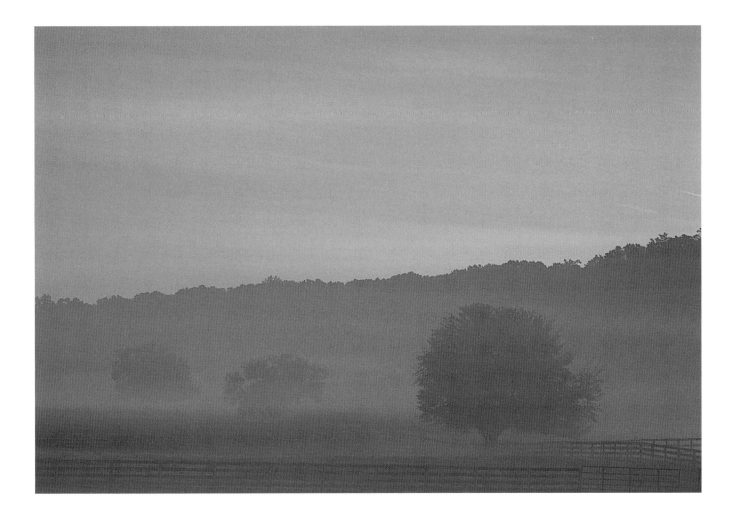

Virginia Bluebell

Gunpowder Falls State Park, Maryland

Nikkor 300mm, f/4 lens
20mm extension tube
81B warming filter
f/4 at $1/60$ second

I was photographing in the shade when bright sun struck the flower for a few seconds. I managed to get only a few images in this light. The shallow depth of field and the extension tube (which enables closer focusing) account for the dramatic falloff of sharpness. The greens are a smooth, almost detail-less background surrounding the flower, creating a "frame within a frame." The only sharp elements in this image are one stamen and the small notch on the petal just below it. I deliberately turned the camera slightly to create the diagonal line of the flower throughout the frame.

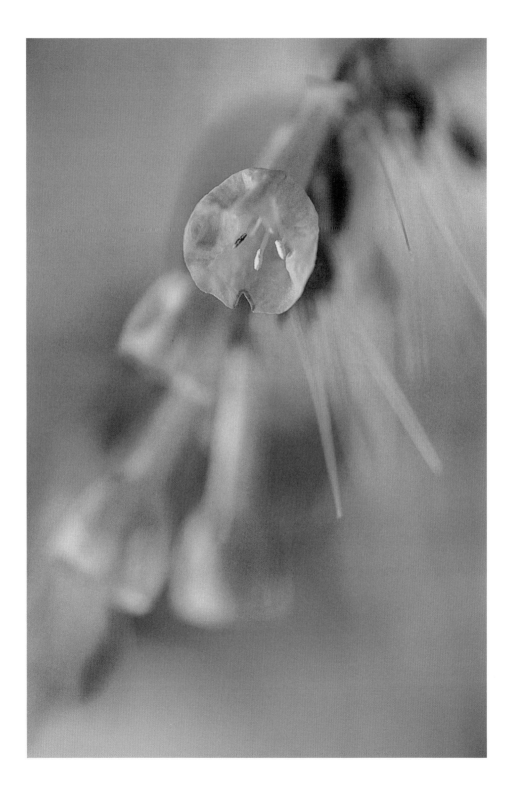

Mountain Dawn

Clingman's Dome, Great Smoky Mountains, Tennessee

Nikkor 300mm, f/4 lens
1.4X teleconverter
81B warming filter
f/11 at 1/4 second

The pastel skies of the early morning and twilight are one of my favorite subjects. In this image, I placed the mountains and the clouds at the bottom of the frame to act as a visual weight to balance the composition and draw attention to the sky, which is 80 percent of the image. This image evokes a peaceful mood. The asymmetry of the three mountain peaks—with two on the right and one on the left—adds to the visual interest.

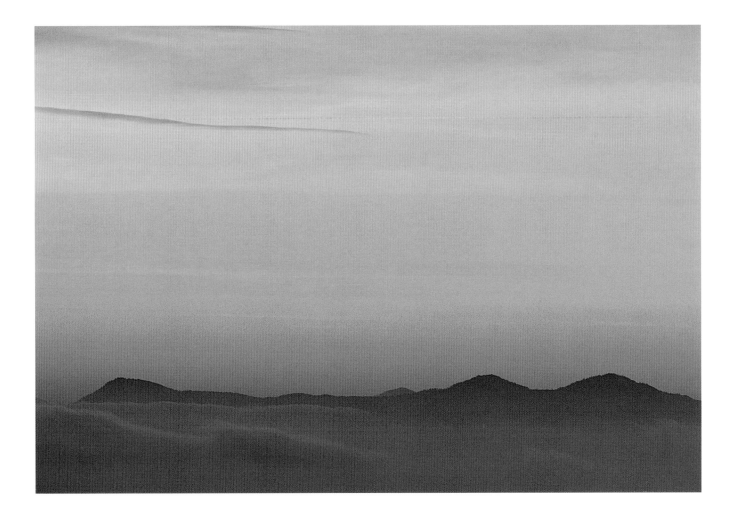

Wildflower Patch

Cylburn Park, Baltimore, Maryland

Nikkor 80–200mm, f/2.8 lens

81B warming filter

(This is a slide "sandwich." Two different exposures were made of the same image, then both were unmounted and remounted together in a GEPE glassless mount. One transparency was exposed at f/22 at +2, and the second was exposed wide open at +1 and slightly defocused, giving the image a soft, blurry effect.)

Subject selection is always an issue when photographing a large patch of wildflowers. Here, there is a flow from the top left to the bottom right. The diagonal line of white flowers is an integral color and graphic element that accentuates the motion and color contrast of the image. When producing a slide "sandwich," it is important to minimize shadow areas, because defocusing enlarges shadows and can create large, unattractive black holes. The image is composed so that there are no "dead" spots or distractions along the edges and in the corners of the frame.

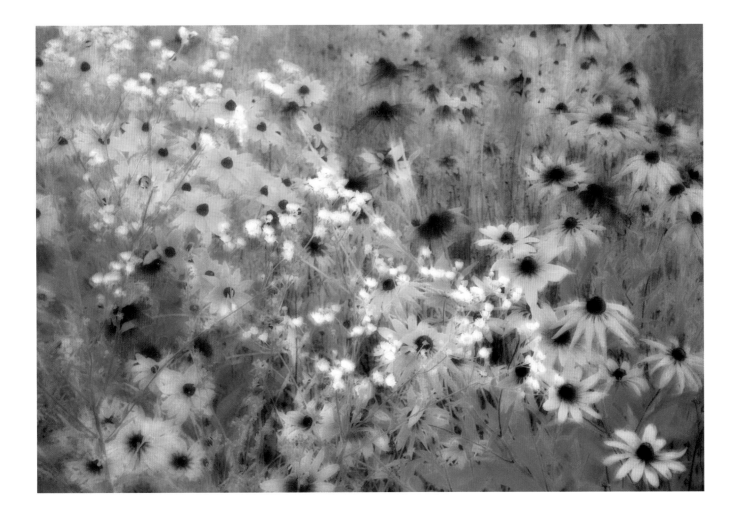

Fall River Reflection

Kancamagus Pass, White Mountains, New Hampshire

Nikkor 80–200mm, f/2.8 lens
81C warming filter and Tiffen 812 filter, stacked
f/22 at 2 seconds

Reflection is the primary subject here. The rocks are supporting material to add balance and texture to the composition. The top and bottom of the frame are balanced. There are more rocks at the top, but the dark line in the bottom third of the frame separates the two color bands, giving more visual weight to the bottom. The warming filter brightens the gold, and the Tiffen 812 filter slightly brightens the red. As a result, the rocks turn a bit purplish. This is more of an abstract, so accurate color rendering is not important. The relatively slow shutter speed softens the water surface, creating a glassy effect.

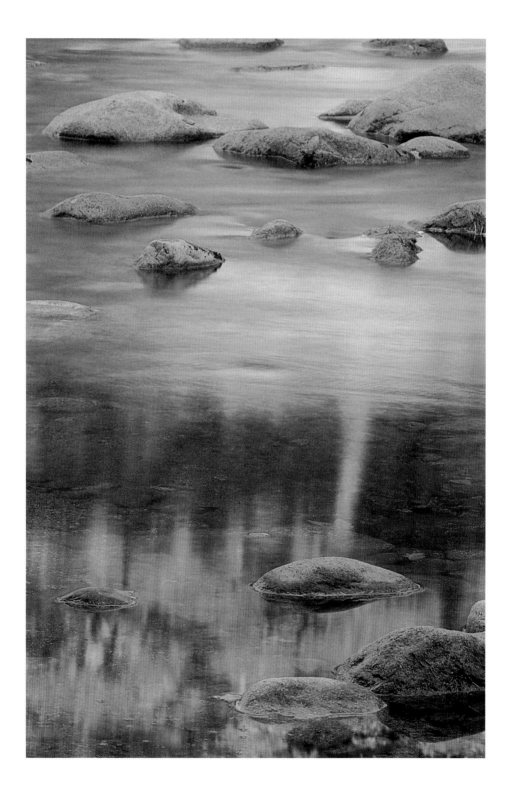

Colorful Web

Roan Mountain, North Carolina

Nikkor 80–200mm, f/4.5 lens
Nikon 3T close-up diopter
81B warming filter
f/8 at ¹/₁₅ second

It was important to get the rhododendron behind the web completely out of focus to create a soft, colorful background. I was also looking for a nice, clean section of the web to create a diagonal line to move through the color. Photographing at f/8 was enough to blur the background yet keep the web mostly sharp. Stopping down further to f/11 or f/16 would have sharpened the background to the point of distraction. Opening up further to f/5.6 or f/4 would have resulted in a softer background but an uncomfortably soft spider web. Since there is no discernible horizon, I was able to create a diagonal line within the web by turning the camera on the tripod.

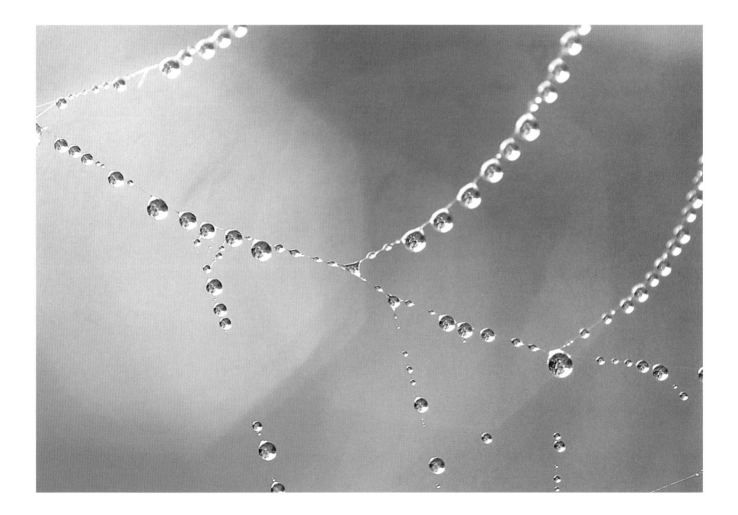

Early Spring Stream

Great Smoky Mountains National Park, Tennessee

Nikkor 80–200mm, f/2.8 lens
81C warming filter
f/22 at 1 second for each exposure (double exposure)

The early spring green and the blue of the sky reflection are the obvious reasons for making this image. The double exposure was created by taking two exposures at 1 second each of the same scene. Since the water is constantly moving and changing, two exposures back to back create a more ethereal appearance. The telephoto lens was used to isolate and compress the C curve of the backwash of the waves and to crop out all extraneous rocks and sticks. Placing the rocks at the extreme top right of the frame directs the eye downward through the frame by way of the C curve. It's important to know your location. This scene exists in the Smokies in late April to early May from about 9 AM to 11 AM, and only on bright, blue-sky days.

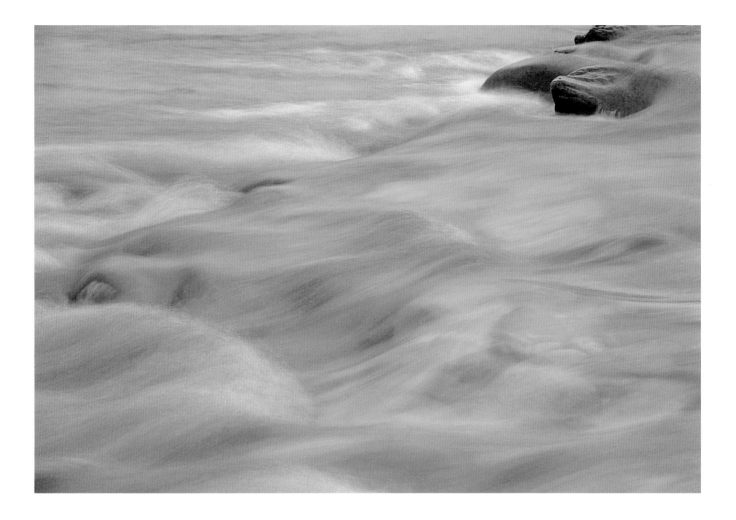

Larkspur and Muted Color

Westminster, Maryland

Nikkor 300mm, f/4.5 lens
32mm extension tube
81B warming filter
f/8 at 1/4 second

Summer roadside wildflowers provide great opportunities for image making. This one was made just as sunlight struck the landscape in the upper background. The harshness of the sunlight became a muted background tonality when thrown out of focus. The shallow depth of field blends all the background flower colors. The larkspur repetition is a unifying element that divides the frame into three rectangles. Using or creating graphic elements such as squares, rectangles, circles, or triangles within the frame is good design. Placing the bottom of the in-focus larkspur close to but not touching the edge of the frame creates visual tension. It is important to have a subject either included in the frame or dramatically cut off. Subjects that just barely touch the edge of the frame are a distraction and make for weak composition.

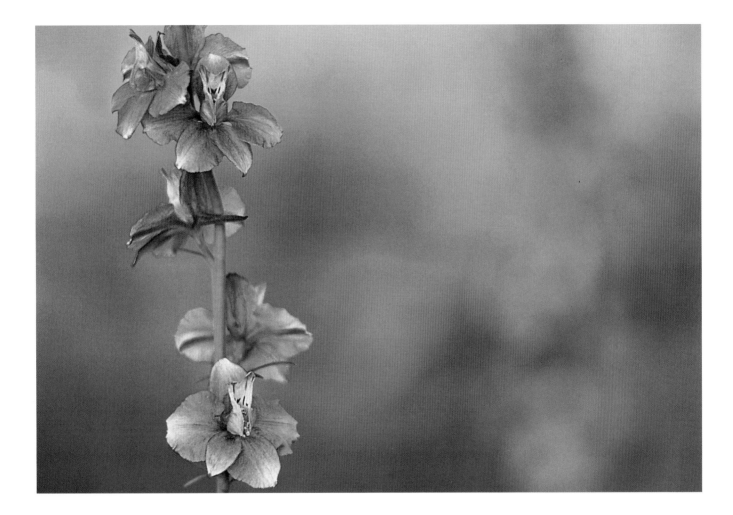

Suspended Red Leaf

Childs Park, Delaware Water Gap National Recreation Area, Pennsylvania

Nikkor 80–200mm, f/2.8 lens
Singh Ray red intensifying filter
f/8 at 1 second

This was a fleeting opportunity. The golden light behind the subject is direct sunlight far in the background. When thrown out of focus, hot highlights become muted, detail-less background elements. Placing the backlit red leaf against the green portion of the background creates color contrast and balance between the leaf and the yellow highlight. Normally, the twigs would be too "busy," but the strong color contrast and shallow depth of field mute the impact of the twigs and help draw attention to the leaf, then to the yellow area. The backlight lasted about 30 seconds. When the leaf went "dark," time was up.

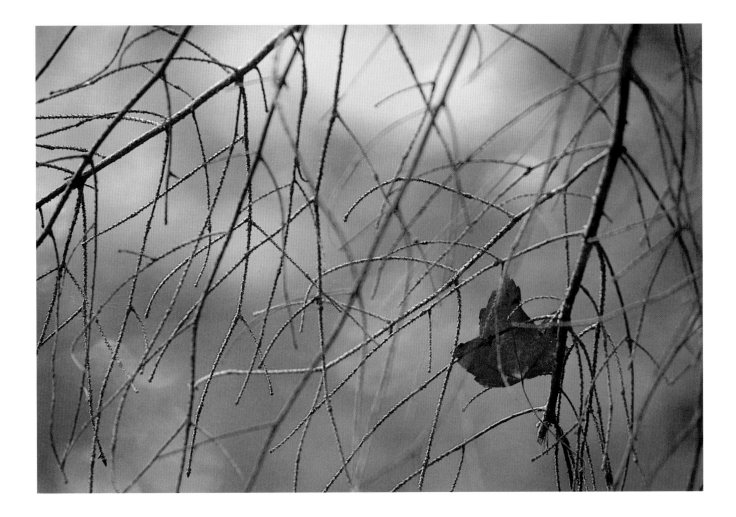

Golden Brook

Childs Park, Delaware Water Gap National Recreation Area, Pennsylvania

Nikkor 35–70, f/2.8 lens
81C warming filter
f/4 at ¹/₈ second

Bright sun shining on yellow fall leaves and reflecting color into the stream created this scene. But it was visible only by looking at the water at a low angle when kneeling down, which is a good practice when composing reflections. Low angles lengthen the areas of color, like lengthening a shadow. I wanted to preserve the slow, lavalike movement of the water and maintain the golden texture. I achieved both goals by using a shallow depth of field, f/4, which results in a faster shutter speed. The faster shutter speed slows the movement of the water, preserving the texture and lines. Only a small area near the bottom of the frame is sharp, but it is enough to hold the viewer's attention and to convey the feeling of color, texture, and movement.

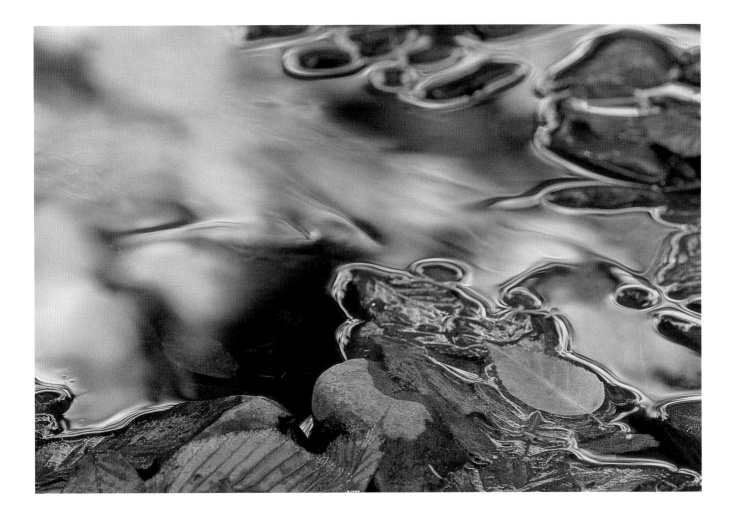

Reeds and Specular Highlights

Hidden Lake, Delaware Water Gap National Recreation Area, Pennsylvania

Nikkor 80–200mm, f/2.8 lens
20mm extension tube
f/2.8 at $^1/_{125}$ second

In direct sunlight, bright specular highlights, or sparkles, appear on water. In this image, the lens is wide open and focused on the reeds, with the highlights in the background. This setup throws the background out of focus, which enlarges the highlights. Bright highlights take on the shape of the lens diaphragm. Using a small aperture creates polygons, whereas using the largest aperture, as in this image, creates circles. All the reeds except one are running out of the frame, drawing attention to the backlit tip of the fully shown reed. Focus is critical when photographing at a wide aperture, and care was taken to square up or to have the lens in the same plane as the backlit reed to get as much sharpness as possible. Because the water was constantly moving, the frame created around the single reed was a bit of luck.

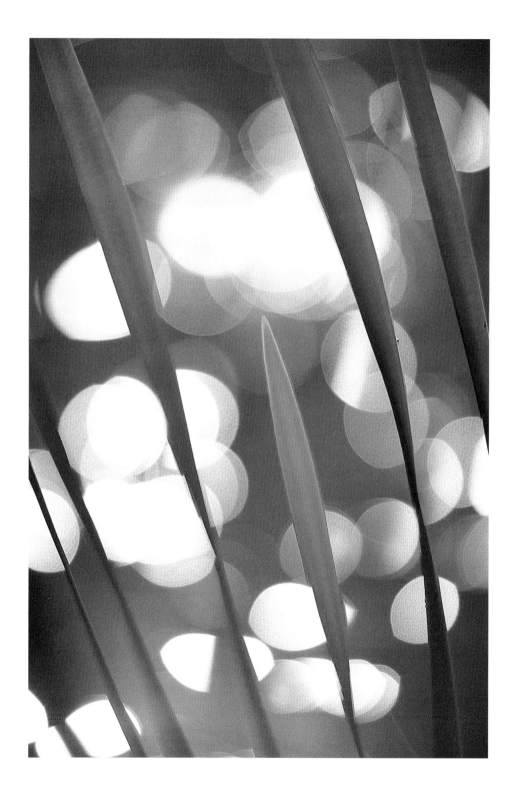

Leaf in Ice

McCollough's Landing, Laurel, Maryland

Nikkor 105mm, f/2.8 macro lens
81B warming filter
f/16 at 1 second

This is a great situation. The leaf, almost totally intact, is flat under a translucent layer of ice. The cold blue color of the leaf is juxtaposed with the warm tone of the background. Juxtaposing warm and cool tonalities is visually stimulating. Notice that all three corners of the subject and the stem are cut off, and the camera is positioned so that the diagonal line doesn't go corner to corner, cutting the frame in half. Physical position was important here, because as I rotated around the subject looking in the viewfinder, I noticed that the purple specks reflecting the blue sky would change intensity and even disappear as my angle to the subject changed.

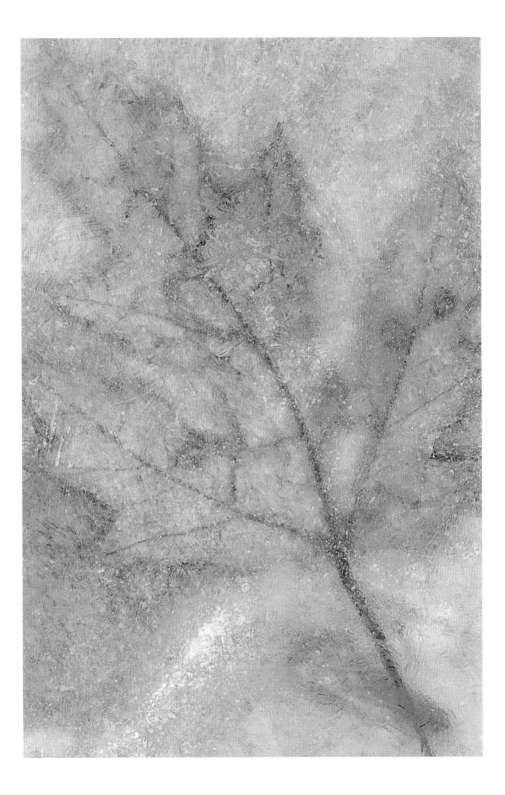

"It's not about going to new places, it's about seeing with new eyes."

—Jay Maisel

Spring Mist

Great Smoky Mountains National Park, Tennessee

Nikkor 20–35mm, f/2.8 lens
f/22 at ¹⁄₂ second

Because most of this image consists of the leaves framing the distant trees, it was important to select an exposure that preserved the muted green of the leaves. Normally, fog is metered at about +1. In that case, the leaf canopy would have been almost black, resulting in a heavy or "blocked up" image. By metering the fog at +2, the fog lightened, evoking a more uplifting feeling, and the soft greens became apparent, adding to the light mood of the scene.

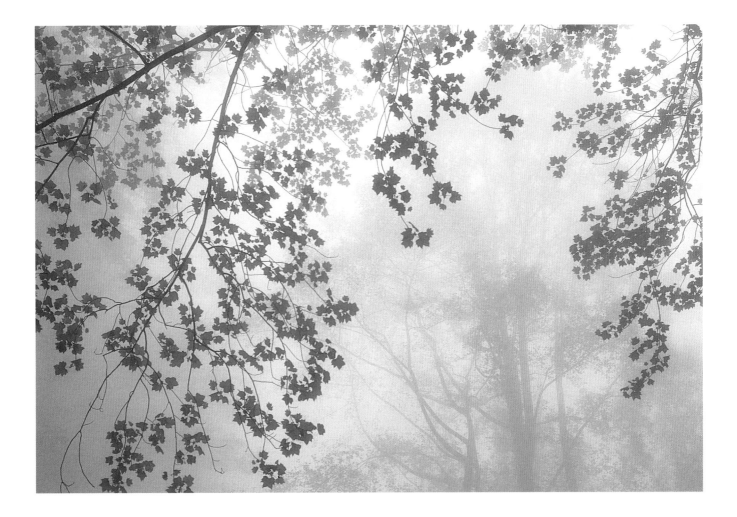

Water Lily

Holt Park, Baltimore, Maryland

Nikkor 300mm, f/4 lens
1.4X teleconverter and 20mm extension tube
81A warming filter
f/16 at 1 second

The pristine appearance of this water lily, aside from the small black speck, is amazing. I could only get about three feet from the subject, since it was out in a pond. The idea here was to be positioned so the diffused light "lit up" the flower. Even moving a few inches to either side affected the degree of brilliance of the light. I wanted the visual weight to be bottom center for balance. Notice the balance throughout the entire frame—in all four corners—and among the petals at the bottom center. It is a good idea, whenever possible, to fill the frame with the subject.

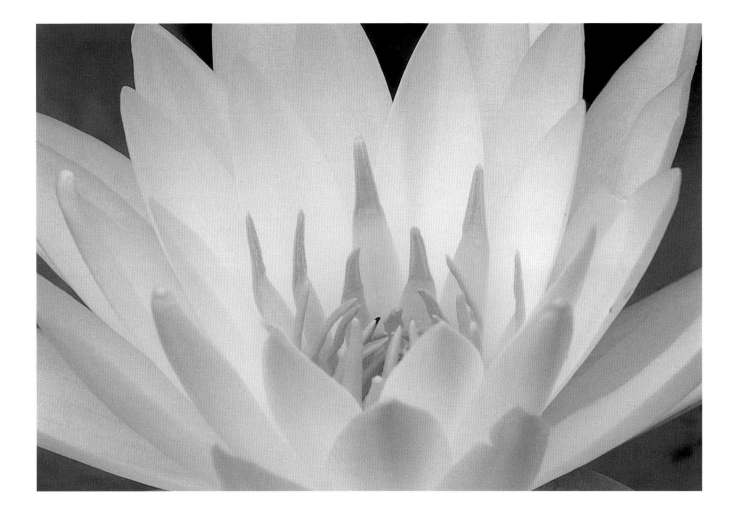

Spring Flowering Trees

Great Smoky Mountains, Tennessee

Nikkor 80–200mm, f/2.8 lens
81B warming filter
f/11 at ¹/₂ second

The point of this image is to express springtime, a time of renewal. The sparseness of the leaves and new growth allows the image to breathe. The openness of the dogwood flowers allows the viewer to see past them to the early spring tonalities of the hillside in the distant background. The tree trunks were placed somewhat in the center of the frame to create a sense of calmness and stability. Another point of interest is the repetition of the V shapes of the limbs.

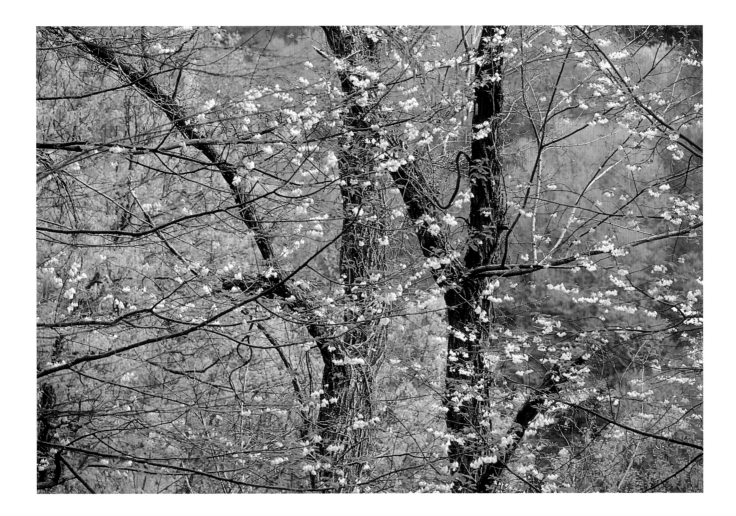

Soft Red Fall Scenic

Great Falls National Park, Maryland

Nikkor 80–200mm, f/2.8 lens
Singh Ray diffusion and red intensifying filters
f/16 at ¹/₂ second
(This is a slide "sandwich." Two different exposures were made of the same image, then unmounted and remounted in a GEPE glassless mount. One transparency was exposed at f/22 at +2, and the second was exposed at wide open at +1 and slightly defocused.)

A combination of filters, effects, and techniques was used to create this image. A red intensifier was added to pump up the red. A diffusion filter was used to brighten and soften the image. The sandwich technique added contrast, and the diffusion filter used on both of the sandwiched images created the ghost image around the backlit leaves. The muted hillside in the shade in the background is unobtrusive and calls attention to the graphic and color. The three tree trunks are gently leaning to the right, creating a sense of motion.

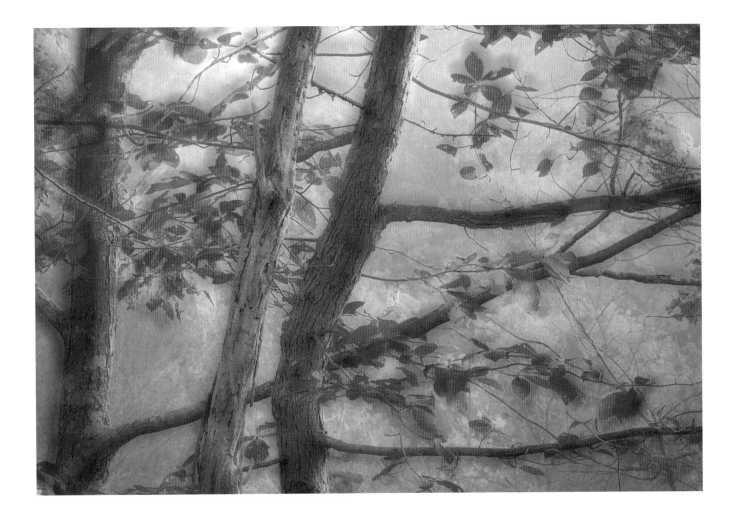

Red Berries through Window

Longwood Gardens, Kennett Square, Pennsylvania

Nikkor 35–70mm, f/2.8 lens
Singh Ray red intensifying filter
f/22 at ¹/₂ second

It is a good idea to keep an eye out for pictures even when you have a pre-conceived image in mind. While waiting to get into a flower conservatory to photograph daylilies and primroses, I was pacing around in the vestibule and spotted this incredible situation. A twig with red berries had fallen against the dewy window. It was composed in such a way that the blue sky was framed by the V shape of the twigs. Almost all I had to do was point and shoot. I went back the next day in the same weather conditions and at the same time, but the image didn't exist. The one-degree movement of the sun had placed it behind the roof, and it didn't light the twigs and red berries at all. The lesson is to photograph a scene when you see it. There is no guarantee that it will exist at a later time, even the next day. Luckily, I made many different compositions and numerous in-camera dupes.

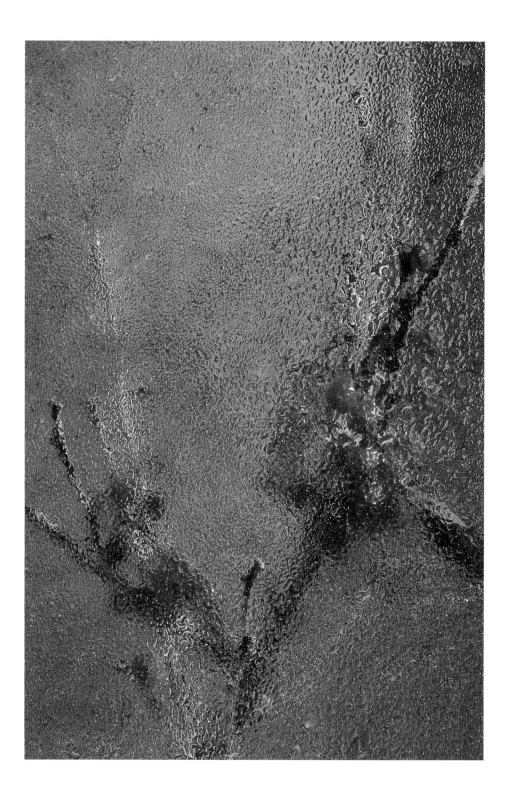

Greenbriar Reflection Rapids

Great Smoky Mountains, Tennessee

Nikkor 300mm, f/4 lens
81B warming filter
f/22 at 1 second

It's important to learn the characteristics of photography locations. This scene appears in late April to early May in the Greenbriar area of the Great Smoky Mountains from about 5 PM to 6:30 PM. Notice that there are three elements in this image: the colored rock and water at the top; the middle waterfall; and the bottom rocks, which add visual weight and balance the dense reflection color and rock graphic at the top of the frame. The lime-green tonality at the top of the frame is a reflection of early spring colors from the trees across the stream, and the blue tonality is from the sky.

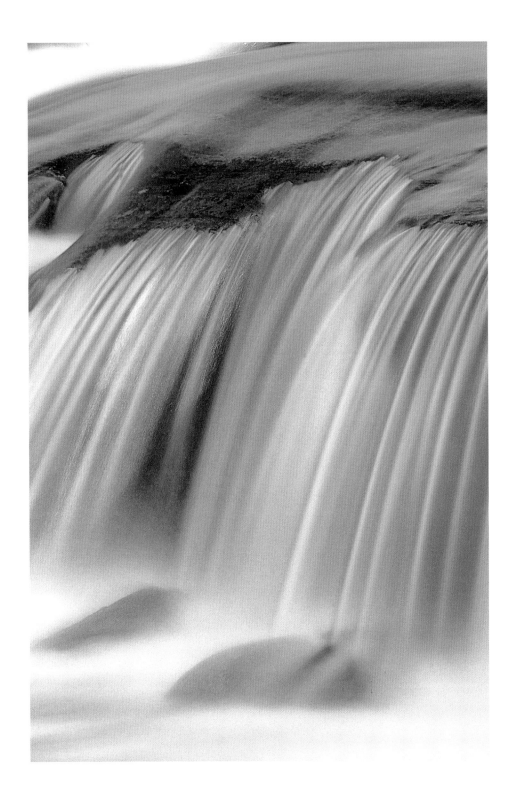

Swift River Rocks and Reflection

Kancamagus Pass, White Mountains, New Hampshire

Nikkor 80–200mm, f/2.8 lens
Singh Ray color intensifying filter
f/22 at 8 seconds

I try to get as much color as possible into every image I make. Unusual here
is that the graphic weight of the image sits at the top of the frame. Just above
the rocks, hard sunlight was shining onto the water, washing out the color, so
to create a balance, I pushed the rocks farther up in the frame, creating an area
of strong reflected color in the bottom three-quarters. This large area of color
balances the graphic of the rocks.

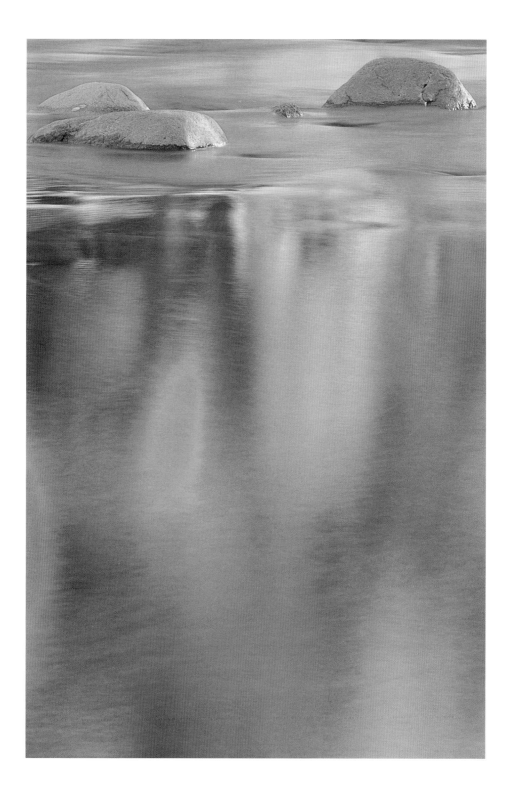

Orange Dawn

Acadia National Park, Maine

Nikkor 80–200mm, f/2.8 lens
1.4X teleconverter
81C warming filter
f/22 at 4 seconds

This dawn light and orange reflection were unusual for Acadia. I wanted to get the longest exposure possible to get the moving orange water to paint over the frame, filling in the color. Placing the hills in the bottom third of the frame gives the image its visual weight. Even though the orange was quite nice, the 81C warming filter intensified the color. It is a good learning experience to photograph a scene both with and without a filter to see the varying effects. The hills were composed to allow the viewer to gently roll through the frame from left to right.

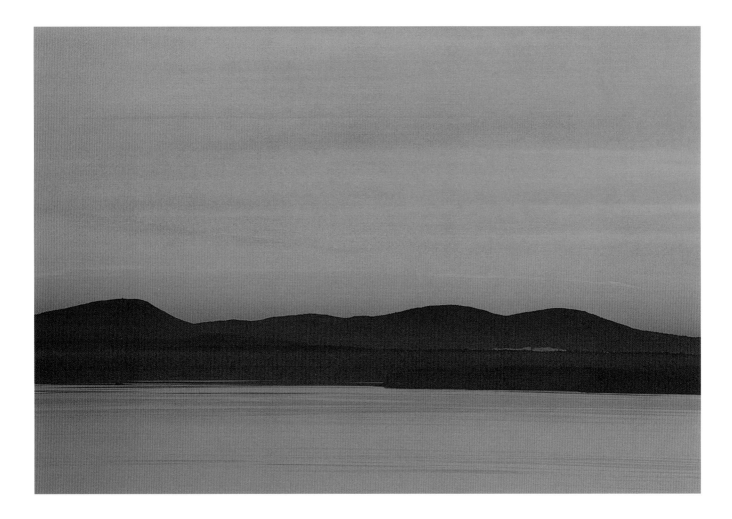

Cherry Tree Abstract

National Arboretum, Washington, DC

Nikkor 35–70mm, f/2.8 lens
81B warming filter
(Eight exposures at f/16, each at $^1/_{15}$ second, while "shaking"
 the camera in short, irregular, up and down movements)

The many colors and textures of this scene (sparse, early spring greens; graphic tree trunks; bright white cherry tree; blue sky), along with the inherent separation, make this an interesting image. The color and graphic contrasts are stark. Keeping the camera movement constrained gave a tight abstract while retaining the graphic integrity of the subjects.

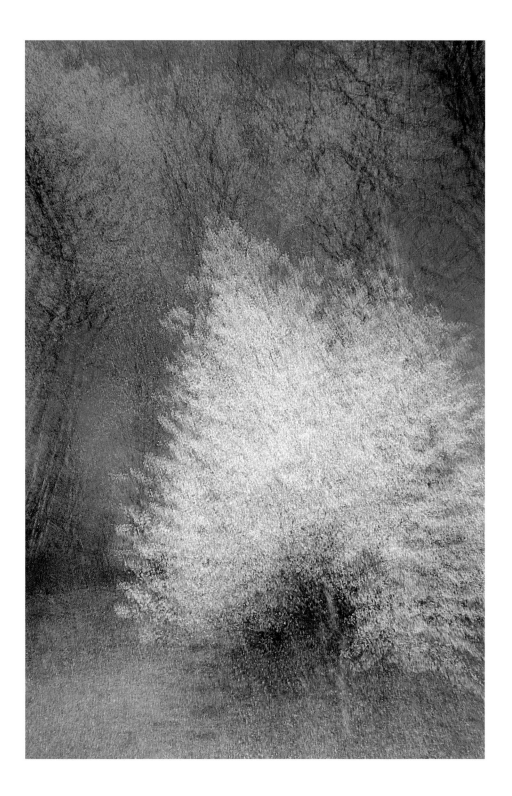

Spanish Moss and Azaleas

Savannah, Georgia

Nikkor 80–200mm, f/2.8 lens
81B warming filter
(This is a slide "sandwich." Two different exposures were made of the same image, then unmounted and remounted in a GEPE glassless mount. One transparency was exposed at f/22 at +2, and the second was exposed at wide open at +1 and slightly defocused.)

I discovered this road lined with azaleas, dogwoods, and Spanish moss in an old cemetery in Savannah. The sandwich technique is a "soft look" technique, although high contrast. I was trying to find a graphic tree surrounded by Spanish moss, dogwood, and azalea. Flat light created low contrast, therefore alleviating shadows, which should be avoided when using the slide sandwich technique. This technique is most effective in bright overcast light.

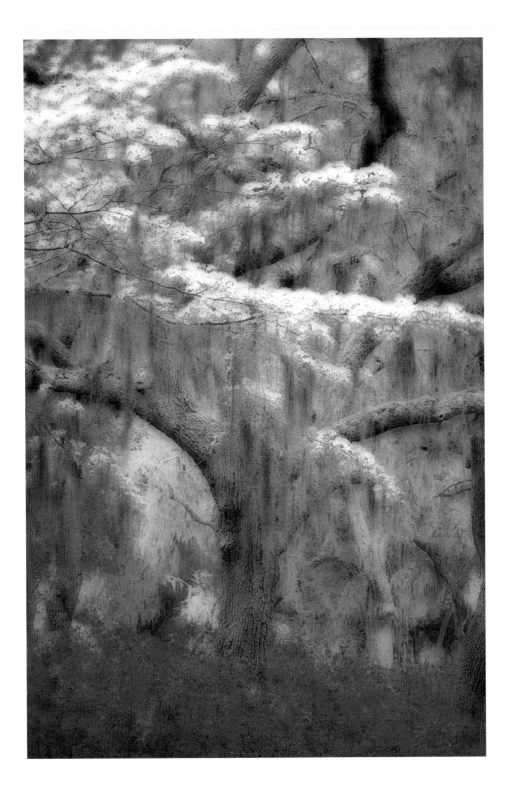

Cumberland Falls

Cumberland Falls State Park, Kentucky

Nikkor 80–200mm, f/2.8 lens
2X teleconverter
Three-stop neutral density filter, 81B warming filter,
* polarizing filter*
f/22 at 6 seconds

Three filters were used to create this image. First, the image was photographed in bright sunlight. To get the slowest possible shutter speed, the three-stop neutral density filter was used. Next, the polarizer, used to remove glare and reveal the green moss beneath the water, added two more stops to the exposure. Without these filters, the exposure was 1/4 second. Finally, the warming filter was added to put some warmth back into the scene, which was a little washed out by the bright sunlight. Normally, long exposures in bright sunlight result in a washed-out, detail-less white area. But here, the lines created by the falls were so strong that there was no loss of detail.

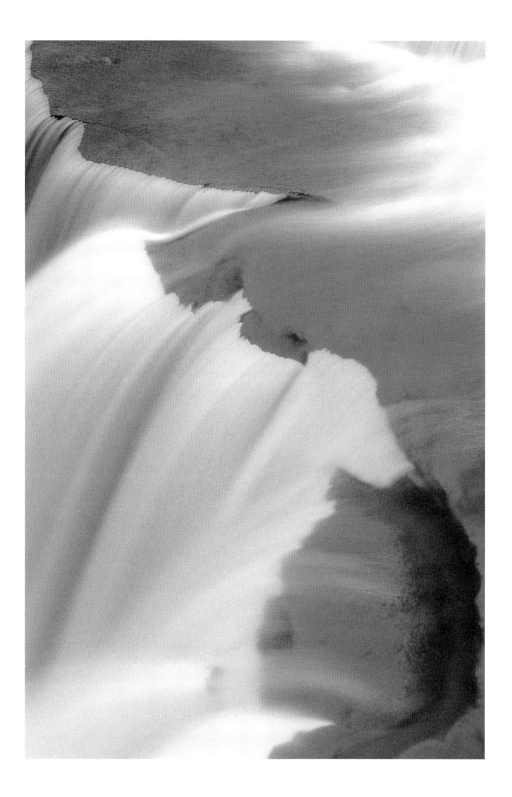

Jordan Pond Rock and the Bubbles

Acadia National Park, Maine

Nikkor 80–200mm, f/2.8 lens
81B warming filter
f/22 at ¹/₂ second

Every so often, one comes across an image that composes itself. As I walked around the pond, the small boulder was just beginning to catch the sunlight, creating a perfect reflection that was also a very appealing graphic. The soft blue of the morning sky created the tonality of the water. The rhythm of the distant hills divided the frame into one-third on the left and two-thirds on the right. The V of the merging hills created a frame into which the rock fit perfectly.

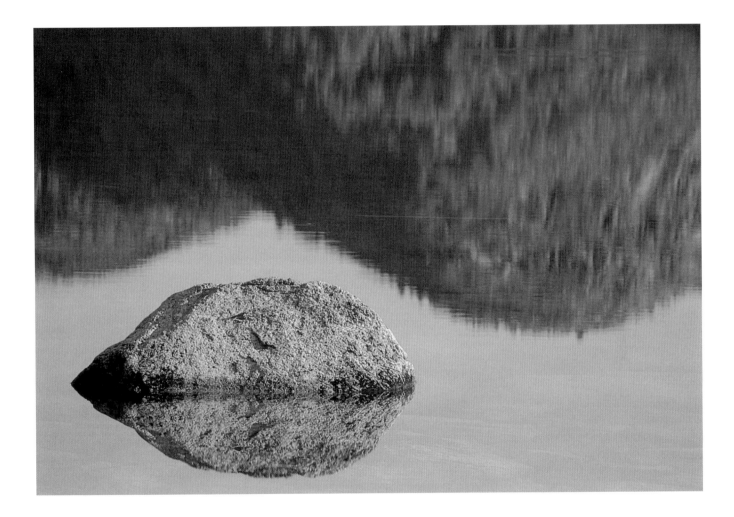

Leaves on Frozen Pond

Laurel, Maryland

Nikkor 80–200mm, f/2.8 lens
81C warming filter, polarizing filter
f/22 at 1 second

On a frozen pond full of leaves, subject selection is the key. I always strive for simplicity and balance. In this case, several elements are worthy of note. The balance is primarily of the "holes." The bottom center and the two areas to the immediate upper left and right of the bottom center hole are the visual weight. Looking at the top from left to right, there is a chiaroscuro pattern of leaves and dark, frozen water.

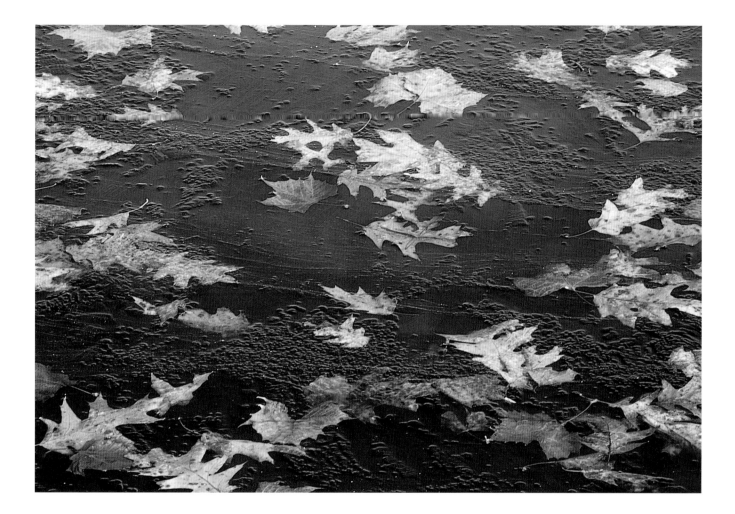

"A picture is the expression of an impression. If the beautiful were not in us, how would we ever recognize it?"

—Ernst Haas

Azaleas and Duckweed

Magnolia Gardens, Charleston, South Carolina

Nikkor 35–70mm, f/2.8 lens
81B warming filter
(Eight exposures at f/16, each at $^1/_{125}$ second,
 zooming in a bit for each exposure)

The color contrast between the green duckweed, pink azaleas, and blue bluebells is the reason for making the image. Placing the azaleas in the center bottom of the frame provides stability and a visual anchor for the viewer. Because the bluebells are off-axis, they went completely out of focus and became a supportive, muted pastel tonality. The duckweed green pushes the azalea pink forward. The resulting image is an impressionist one in which the viewer's attention is directed toward the azaleas.

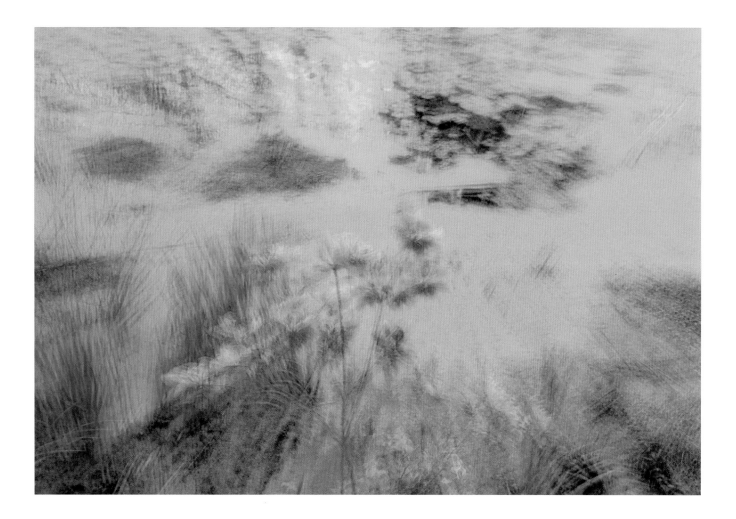

Seashell and Sand Pattern

Cape May, New Jersey

Nikkor 105mm, f/2.8 macro lens
81B warming filter
f/16 at 1 second

The very small patterns in this image were created by waves pulling seashells out of the sand while receding into the ocean. The shell at the top is about the size of a dime. Having the shell very close to the top of the frame creates visual tension. The eye quickly views the shell, then flows downward through the wonderful, featherlike sand pattern radiating from it. The black sand mixed in is indigenous to Cape May and offers great opportunities for graphic interpretations. The best time for creating these types of images is during bright overcast, which acts like a natural soft box, accentuating the color, texture, and tonality of the sand.

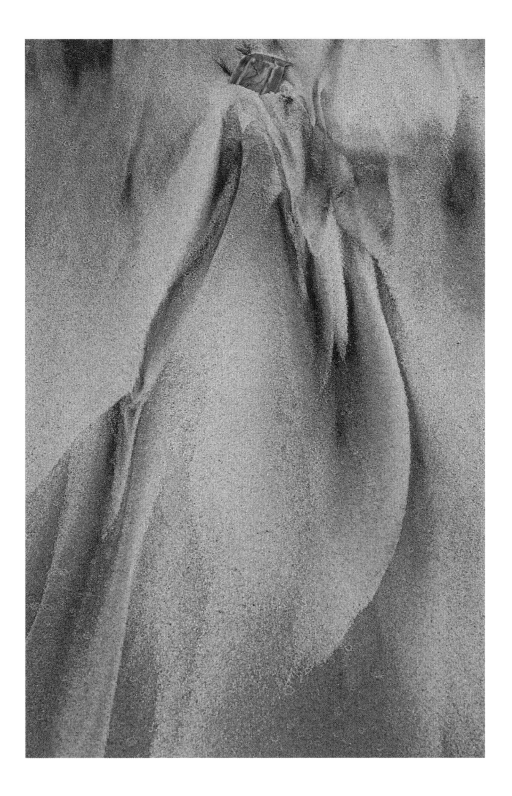

Abstract Reflection

Anvil Rock, Grandfather Mountain, North Carolina

Nikkor 80–200mm, f/2.8 lens
20mm extension tube
81EF warming filter
f/22 at 2 seconds

This dewy image appeared on a picnic table outside my cabin. The color is the reflection of trees and sky. Water has to be in the shade for a reflection to take. Once water is sunlit, it almost always becomes washed out and the reflection can lose its impact. Camera angle was important; I wanted to use the sky to create the blue edges of the graphic. The 81EF warming filter was used because the image was in deep shade on a bright, sunny day. Subject selection is the key here. These water patterns covered the entire table, so I chose a portion with good rhythm, balance, and separation.

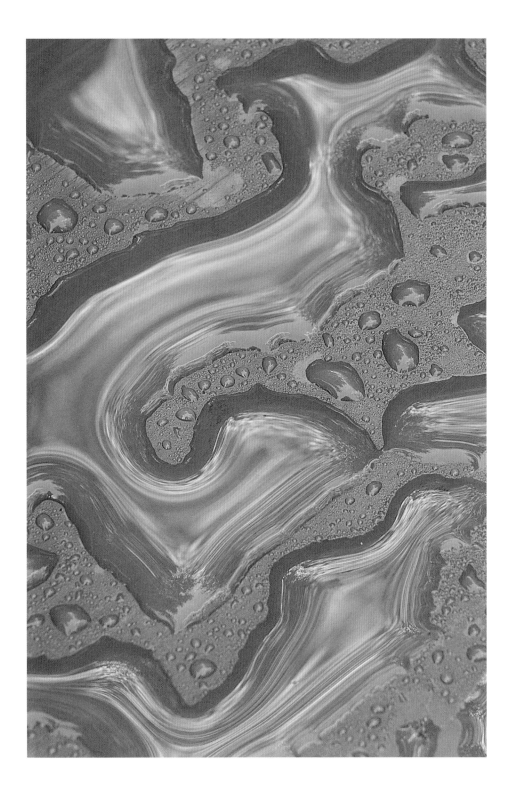

Ocean Waves and Shoreline Rocks

York Beach, Maine

Nikkor 80–200mm, f/2.8 lens

f/22 at 30 seconds (this is actually a 15-second exposure that was doubled for reciprocity failure, the breakdown of the reciprocal relationship between f-stop and shutter speed that can occur at slow shutter speeds)

Note the graphic contrast of the soft ocean waves and the hard rocks on the beach. The thin rectangle of rocks at the bottom of the frame acts as a visual anchor as the breaking waves paint over the frame for the long 30-second exposure, creating the feathery abstract. I did not use a filter because I decided to allow the water to go blue, which occurs with Fuji Velvia film under overcast or low-contrast conditions without the use of a warming filter. It is important to learn the characteristics of the films you use.

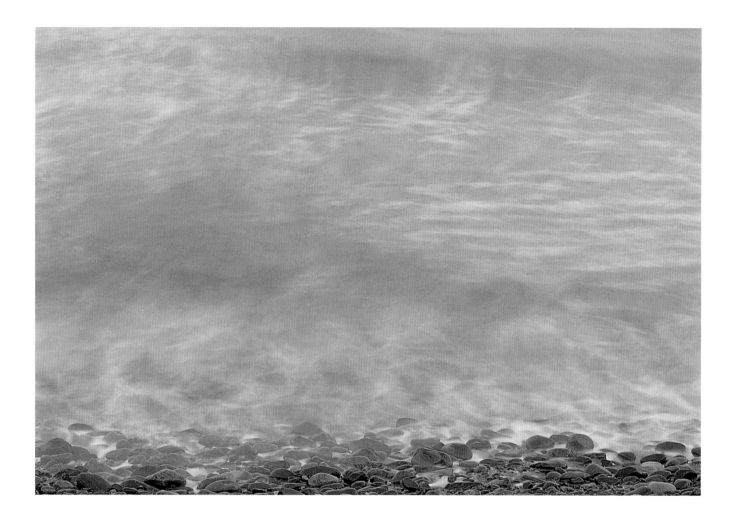

Winter Storm

Loch Raven Watershed, Towson, Maryland

Nikkor 35–70mm, f/2.8 lens
81A warming filter
f/11 at ¹/₃₀ second

This is a composition of lines. I used the fast shutter speed to stop the movement of the falling snow in order to show the lines. What results is a muted screen effect, which would not be visible at a longer exposure; actually, the image would be clear at a longer exposure, as quickly moving subjects don't record on film at long exposures. The "horizon line" is kept in the lower portion of the frame. The greatest challenge here was to avoid merging the trees and to keep as much separation in the scene as possible. This took some time peering through the viewfinder, looking at every tree and moving the camera slightly to keep elements separated. I took care during the composition process to place the most prominent group of three trees in the bottom right portion of the frame.

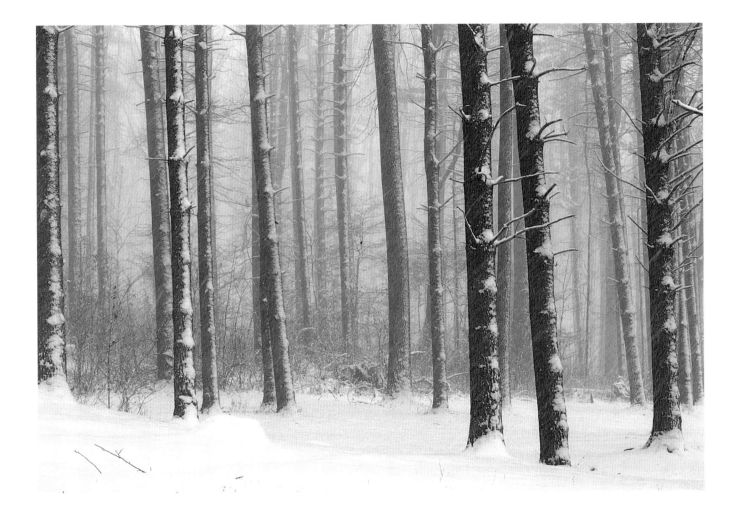

Trees in the Mist

Grandfather Mountain, North Carolina

Nikkor 80–200mm, f/2.8 lens
f/22 at 1 second

My adrenaline gets going when I see a translucent mist. Mist creates separation, and mediocre subjects become magical images. On clear days, the merging of the foreground and background trees renders this scene much too busy. Mist creates beautiful separation and amplifies the frame-within-a-frame composition. Adding to the mood is a green cast to the mist at Grandfather Mountain that I've not seen elsewhere. It is important to know the different qualities of light in the locations one visits.

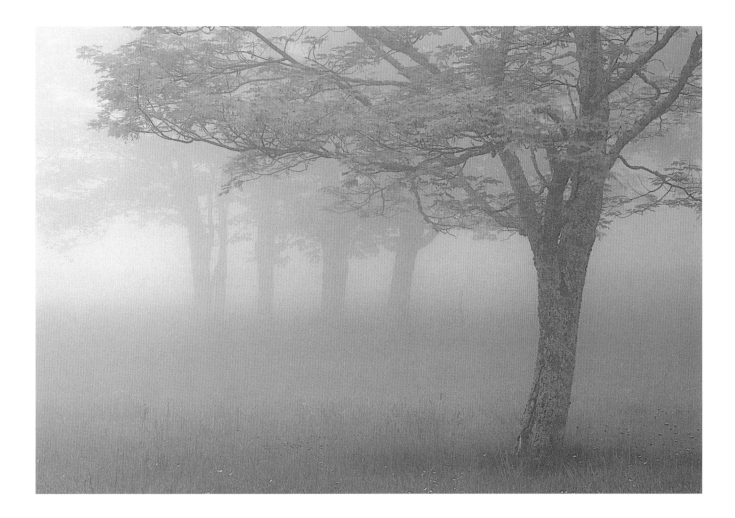

Mist Explosion

Williams Pond, Worthington Valley, Maryland

Nikkor 35–70mm, f/2.8 lens
81C warming filter
f/8 at $^1/_{60}$ second

This image is an example of knowing the lay of the land where one lives. This scene, in northern Baltimore County, occurs in mornings of mid-September for only about two weeks, after which the sun moves south (to the right). As one moves left to keep the sun behind the tree, the tree merges with the tree group on the right, losing the separation. These scenes are subjective and interpretive, so adding a colored gel such as an 81C, 81EF, 10cc magenta, or diffusion filter gives different results. I made an effort to keep the sun out of the center of the frame to avoid a static, bull's-eye composition.

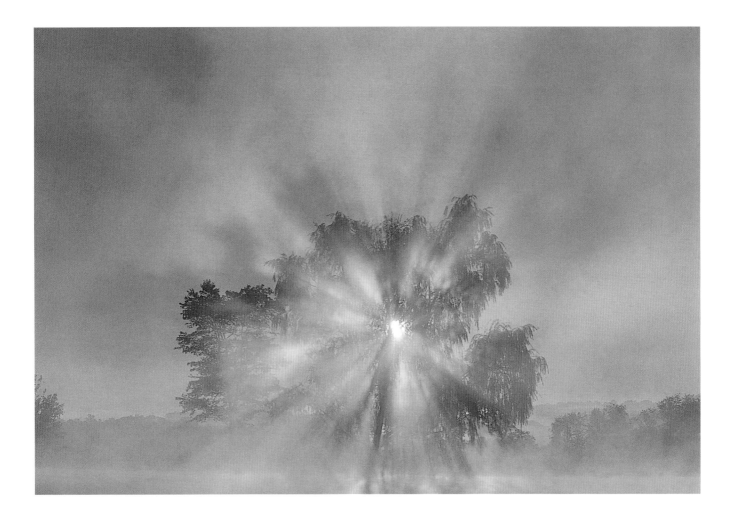

Fall Reflection

Loch Raven Watershed, Towson, Maryland

Nikkor 35–70mm, f/2.8 lens
81C warming filter, polarizing filter
f/8 at 1/15 second

The look of this image is a function of shutter speed. Moving water is like any other moving subject, in that faster shutter speeds stop motion and slower shutter speeds blur motion. My intent here was to stop the motion to create a "brush-stroke" look. The brilliance of the colors has the appearance of acrylic paints. Photographing at the slowest possible shutter speed would make the colors blend together, creating an altogether different look. By shortening the exposure time, the movement is hardened, resulting in the brush strokes that maintain the oblique graphic of the color line.

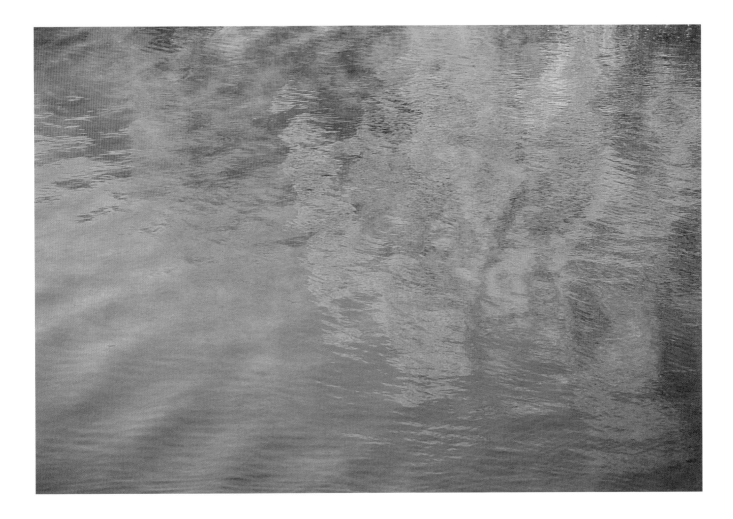

Sunrise through Reeds

Cape May, New Jersey

Nikkor 80–200mm, f/2.8 lens
20mm extension tube
81B warming filter
f/2.8 at ¹/₁₂₅ second

This is a highly graphic image, depicting a circle (the sun), triangles and vertical lines (the reeds), and muted color (the dawn sky). The only time to get this colorful fireball without flare is during marginal light—dawn or dusk—when the sun is low on the horizon. The contrast is low, and flare is far less likely. Photographing at the widest aperture keeps the sun round. To achieve maximum sharpness at a wide-open aperture, the camera, or focal plane, needs to be on the same plane—not at an angle—as the subject. The most prominent reeds run out of the frame, which avoids the distraction that would result if the tops of the reeds were visible just above the sun.

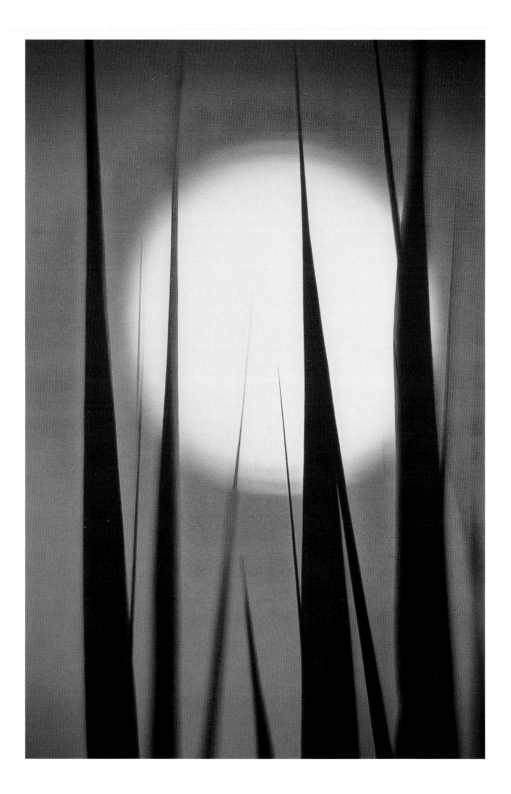

Spring Tree and Reeds

Great Smoky Mountains, Tennessee

Nikkor 35–70mm, f/2.8 lens
81B warming filter
f/22 at ¹⁄₁₂₅ second for each of eight exposures
* while panning the camera upward*

Following the orientation of the subject for multiple exposures maintains its general appearance. Panning in different directions results in a departure from the image to a more abstract appearance. The vertical lines of this scene made the decision an easy one. I wanted to preserve the vertical lines of the spindly background trees while muting the early spring green leaves of the larger foreground tree, creating a soft abstract trace of green tonality overlaying the vertical lines.

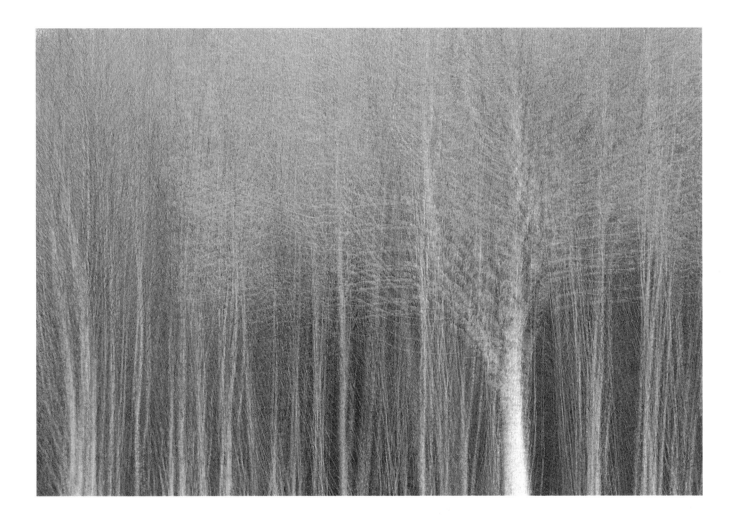

Reeds and Dawn Color Bands

Kingston Lake, New Brunswick, Canada

Nikkor 35–70mm, f/2.8 lens
Tiffen 812 filter
f/16 at 2 seconds

When photographing reeds in water, I look for uncluttered, open, separated patches. When reeds are dense, they become detail-less and unattractive. This image juxtaposes the delicacy of the reeds against the bold color bands of the reflection. The rectangular bands of dawn color are remarkable in their evenness and are the result of my constant search for geometric shapes in nature. The tops of the reeds are cut off to balance the irregular pattern created by their bottoms.

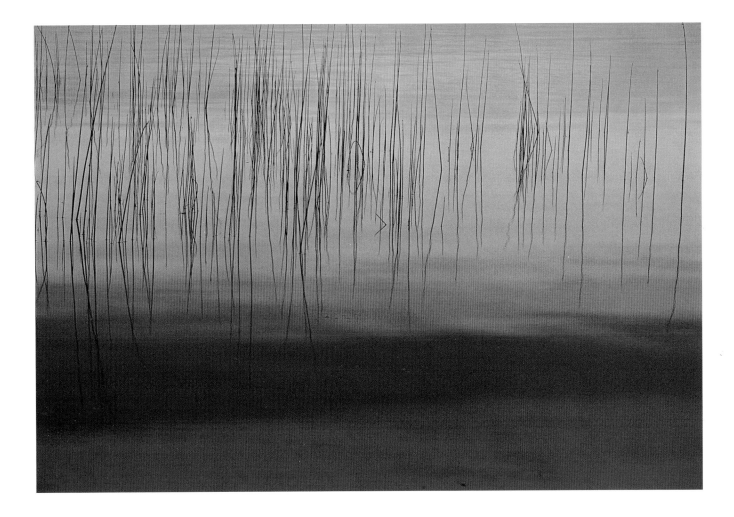

Soft Takeoff

Sanibel Island, Florida

Nikkor 50–135mm, f/3.5 lens
Fill flash at –1²/₃ power
f/22 at 1 second
(Rear curtain synchronization fill flash: at a 1-second exposure, the scene is exposed and shot
as if there were no flash—the flash goes off at the end of the exposure time, freezing the
image at the end of the shot.)

This image was previsualized in that I had the lens and flash set up and went looking for a particular situation. I wanted to photograph a bird in flight using rear curtain synchronization fill flash. I was hoping to get a long exposure of the bird taking off, which would be blurred by movement, and then to pop the flash at the end to create some defined lines. This final image is a kind of double exposure; the first exposure is the bird slowly taking off, and the second is the flash exposure. I had an extra bit of luck here: the trees in the upper left corner create a frame for the bird taking flight from the bottom left corner. Also, the tonality and muted quality of the egret are matched by the tonality and muted quality of the clouds.

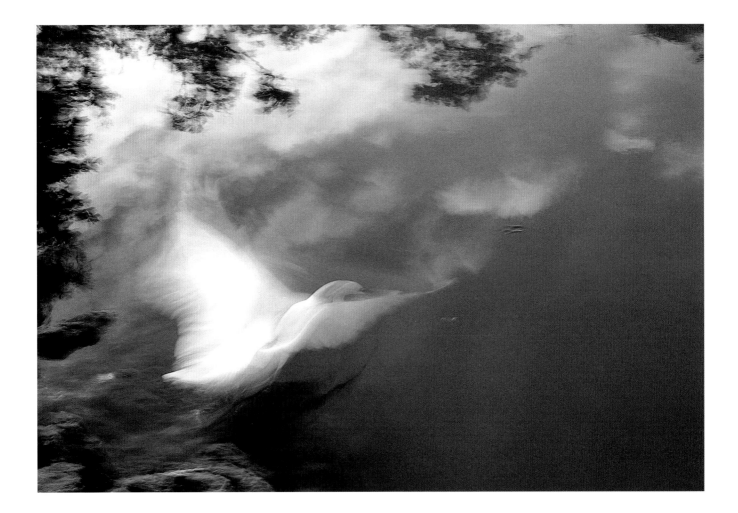

Garden Abstract

Sherwood Gardens, Baltimore, Maryland

Nikkor 35–70mm, f/2.8 lens
81B warming filter
(Eight multiple exposures at f/16, each at $^1/_{15}$ second,
while moving randomly, but mostly up and down)

Even though the effect here is abstract, good composition and design rules
still apply. The S curve of the tulips leading to the tree is what caught my eye.
Although the line is blurred by the camera shake and the S curve becomes
distorted, the leading line still takes the viewer into the frame and to the tree.
I was careful to divide the frame into thirds. The tree resides in the upper
third, and the tulips—and the greatest amount of color—take up the bottom
two-thirds. There are also dark spaces in the mass of tulips that are filled in
by employing the multiple exposure technique.

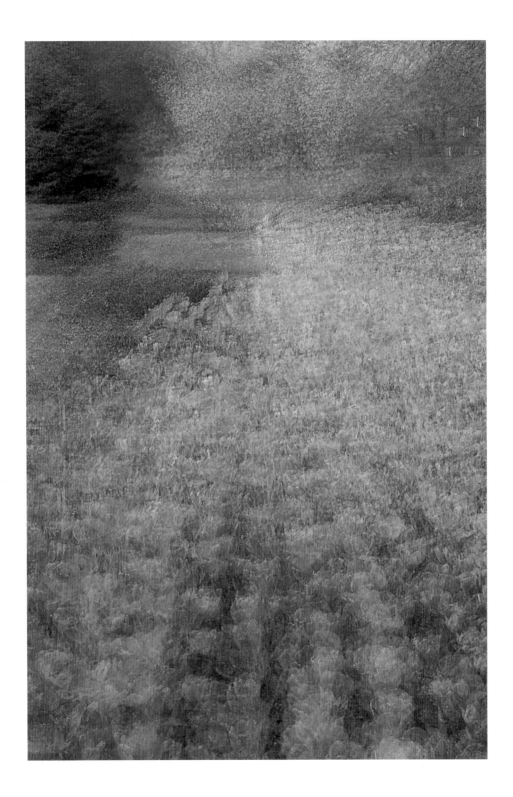

Equipment

Film

Fuji Velvia ISO 50 and Provia F ISO 100

Cameras

Two Nikon F4s

Nikon F3 dedicated to infrared film

Hasselblad X-Pan dedicated to panoramic images

Lenses

Nikkor 20–35mm, f/2.8

Nikkor 35–70mm, f/2.8

Nikkor 80–200mm, f/2.8

Nikkor 300mm, f/4

Nikkor 105mm, f/2.8 macro

Hasselblad X-Pan lenses—30mm, 45mm, 90mm

Accessories

Sigma 1.4X and 2X teleconverters

Nikon extension tubes—8mm, 14mm, 27.5mm, 52.5mm

Nikon SB24 flash with synch cord

Gossen Starlite light meter

Lastolite reflectors and diffusors

Lowe Pro Nature Trekker backpack

Tripods

Gitzo G1349 Carbon Fiber with Gitzo G1377M ball head

Bogen 3221 with Studioball Mini head

Filters

81B, 81C, and 81EF warming filters

Nikon polarizer

10cc Magenta

Tiffen 812

FL-W

Singh Ray diffusion

Singh Ray red intensifier

Singh Ray color intensifier

Singh Ray warm polarizer

Singh Ray blue/gold polarizer

Singh Ray graduated neutral density filters—two-stop/soft edge and three-stop/soft and hard edge

B+W three-stop neutral density

Tiffen Red 25A and B+W 092 infrared filters

Nikon 3T and 4T close-up diopters

Digital Work Stations

Macintosh G4 desktop computer, 1 gig RAM

Macintosh G3 Powerbook, 512 meg RAM

Wacom Intuos 6x8 tablet and 3x5 tablet

Nikon Super Coolscan 4000 ED transparency and film scanner

Epson Perception 2450 flatbed scanner

Epson 1280 printer

LaCie SCSI CD burner

Jaz and Zip drives